SOROLLA

ediciones polígrafa

masterpieces

JOAQUÍN SOROLLA

© 2015 Ediciones Polígrafa, S.A.
Balmes, 54. E-08007 Barcelona
www.edicionespoligrafa.com

© Text: José María Faerna García-Bermejo
English translation: Richard Rees
Proofreading: Helena Casellas
Printed and bound at Comgràfic, Barcelona

ISBN: 84-343-1116-X
Dep. legal: B. 29.551 - 2015 (Printed in Spain)

CONTENTS

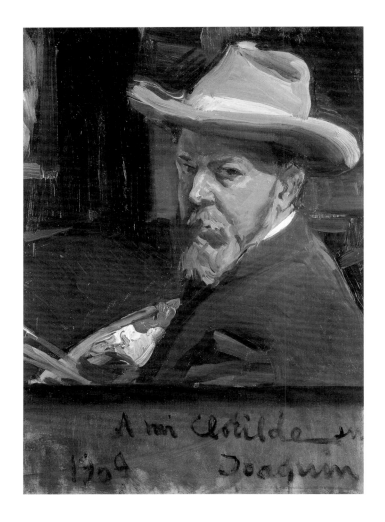

SELF-PORTRAIT. 1909.

JOAQUÍN SOROLLA, A FIN-DE-SIÈCLE PAINTER

One of the most significant phenomena in the art world of the last years of the 20th century was the growing interest in certain manifestations of 19th-century art, which until shortly before had been relegated to a secondary position as denoting conservatism, academicism or the persistence of tradition. This was the case not only of historical and genre painting, but also of certain turn-of-the-century European styles that had not managed to fit into any of the movements that had emerged as part of the defining process of modern painting.

Sorolla is a clear example of this phenomenon. During the first ten or fifteen years of the 20th century he enjoyed extraordinary prestige in much of Europe and, above all, in the United States, accompanied by an equally formidable personal fortune. Such fame was eclipsed after his death in 1923 (although in Spain his celebrity status continued) and it is only in recent years that interest in his work has been rekindled among scholars and collectors. The same applies to some contemporaries of Sorolla's, such as the Scandinavian painters Anders Zorn and P. S. Krøyer, with whom he is often linked, and others like the Catalan Modernistes Ramon Casas and Santiago Rusiñol, with whom he is related less frequently, although he shared some of their most characteristic stylistic traits. Despite the fact that they all executed most of their works in the 20th century, they still tend to be regarded as champions of the 19th-century painting tradition in opposition to the then incipient avant-garde. By virtue of their quest for ways to render the effects of light in the open air, they all have affinities with Impressionism, although it would be a mistake to describe them as Impressionists in the true sense. On the other hand, they shared the same debt to Velázquez, who of all the old masters

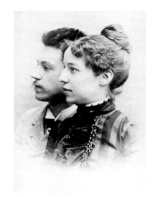
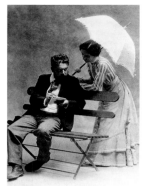

was probably the one considered to be closest to modern sensibility. Lastly, they all undoubtedly regarded themselves as modern artists, despite their position on the fringe of avant-garde innovation.

AN ACADEMIC TRAINING

The artistic training of these painters was almost invariably conventional, their only timid breakaway from academic tradition taking the form of vaguely naturalist concerns. And Joaquín Sorolla y Bastida (Valencia, 1863) was no exception. Born into a family of retailers, after the premature death of their parents he and his sister Concha were brought up at the home of their uncle, the locksmith José Piqueres. At the age of fourteen Joaquín began to attend evening drawing classes at the Escuela de Artesanos in his native city, and in 1878 he enrolled at the Escuela de Bellas Artes de San Carlos, where he studied until 1881. Once he had completed his studies there, the Diputación Provincial de Valencia (Valencia Provincial Council) awarded him a scholarship to study in Rome on condition that he send works back as evidence of his putting the money to good use.

This entirely traditional panorama was tempered by two factors that were to greatly influence Sorolla's subsequent career. The first of these was the adoption by the major Valencian painters of the time (Antonio Muñoz Degrain, Emilio Sala and Francisco Domingo) of a colourist style characterised by free brush strokes and a tendency to render academic subjects such as historical themes in a livelier, more immediate way reminiscent of genre painting. This explains why Sorolla's work broke away very soon from the main stylistic strands of conservative academicism to cultivate naturalism, colour and light as the fundamentals of painting. This tension between naturalism and conventionalism may be observed in the historical paintings from

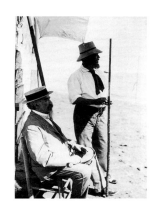

Sorolla with his father-in-law.
Antonio García Pérez, on a
beach in Valencia around 1903.

these early years, such as *May 2nd.*, which won the artist a second-class medal at the Madrid National Exhibition of 1884, *The Shout of the Palleter*, one of the works he presented to the Valencia Provincial Council to obtain the grant that would take him to Rome the following year, and *Father Jofré Protecting a Madman* (p.23), sent from the Italian capital to Valencia in 1887 as stipulated in the scholarship conditions. Although in all three cases the choice of theme obeyed the criteria of a conventional artistic training, the freedom of execution and the painter's interest in rendering the effects of light in the open air—*The Shout of the Palleter* was painted in the Valencia bullring, which Sorolla transformed into a huge studio bathed in sunlight—are far removed from the habitual concerns of the genre and reflect the concerns of Valencian artists like those mentioned above. Equally observable here is the influence of other Spanish artists, like Marià Fortuny i Marsal, who enjoyed considerable international renown at the time.

The other determining factor in Sorolla's formative years was the artist's close contact with the photographer Antonio García Pérez, whose daughter Clotilde he married in 1888. Sorolla met his future father-in-law through the latter's son, Juan Antonio, a fellow student at the Escuela de Bellas Artes. The photographer, noting his son's friend's talent, took him under his wing and provided him with work at his studio as an illuminator. Sorolla was thus not only enabled to leave his uncle José's workshop but also provided with the opportunity to come into very close contact with the photographic image, whose framing, expressive possibilities and systems of light manipulation may be detected in many of his paintings from after 1900, particularly the beach scenes, on which much of his reputation still rests today. Photography greatly influenced many of the painters that in the last quarter of the 19th century sought new procedures

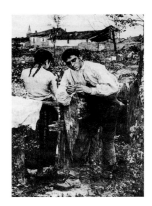

for representing space more in keeping with the superficial character of the painting than with traditional perspective. Indeed some, like Degas or Caillebotte, were true amateur photographers. Although Sorolla never aspired to so much, complicity with his father-in-law left its traces in his portraits of Antonio García (some of which, like the one at the Hispanic Society of New York, showing him engrossed in his tasks in the laboratory). Even so, insufficient attention has been paid to the importance of photography in the configuration of Sorolla's pictorial image.

THE THIRD WAY IN MODERN PAINTING

When around 1890 Sorolla finally returned from Italy and settled in Madrid, his formative period might be regarded as having come to a close. In 1885 the artist had spent some months in Paris, where the Impressionists were beginning to consolidate their position eleven years after their first public appearance as a group in the form of their exhibition at Nadar's studio and having survived the initial period of mockery, commercial failure and frontal rejection. Nevertheless, it would be neither Monet, Renoir, Degas nor Pissarro who would attract the attention of a Sorolla who was barely twenty-two years old, but two non-Impressionists who at that moment were each holding a retrospective at the French capital: Jules Bastien-Lepage and Adolf von Menzel. Bastien-Lepage, who had died prematurely the previous year, cultivated rural painting in a rather cloying version of the realist tradition of Courbet and Millet, although with the clear palette, long brush strokes and the spontaneous fluent execution of Manet. Von Menzel, a German who had turned seventy that year, had produced a vast oeuvre in which, alongside historical and military subjects, genre painting coexisted close to the bidermaier style in which he masterfully created light and atmospheric effects. Both offered

Jules Bastien-Lepage, *Love in the Village*. A work characteristic of Bastien-Lepage's rural realism, wich captured Sorolla's interest on his visit to Paris in 1885.

The garden of the house (which now accommodates the Sorolla Museum) that Sorolla had built in Madrid between 1910 and 1911 was setting for his last open-air paintings.

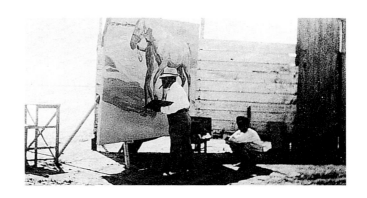

One aspect characteristic of Sorolla's art was the fact that he took the large format, formely reserved almost exclusively for historical painting and other genres restricted to the studio, into the open air. In the photograph, painting *The Horse Bath* in the summer of 1909.

young painters such as Sorolla a kind of third way, acceptable to officialdom and halfway between rampant academicism and radical Impressionism, something like an updated interpretation in terms of technique and register of the colourist quality of the genre painting, replete with narrative, poetic and emotional nuances, which adorned the walls of 19th-century bourgeois homes. On the basis of this example—and that of other borderline artists such as the Americans Sargent and Whistler—, painters like Sorolla, Zorn and Krøyer developed a painterly style that, despite its airs of modernity, gratified the juries of official competitions. Indeed, this painting was an unqualified success at all national and international exhibitions at the turn of the century and, furthermore, cornered the art market until, around 1920, the avant-garde began to relegate it to a secondary position.

REALISM, REGENERATIONISM AND SOCIAL COSTUMBRISMO

The example of Bastien-Lepage would have a twofold effect on the young artist. On the one hand, it would lead him to seek his themes in his immediate surroundings, such as the daily lives of Valencian fishermen, which for Sorolla would be something similar to what rural life had been for the French painter. On the other, it would reinforce his commitment to the natural and his self-confidence when it came to render it unfettered by academic conventions. On these bases, in 1890 he began to develop his own painterly system, which would take two complementary directions: social realism and a kind of updated costumbrismo[1] tinged with social criticism.

The first of these two directions, which Sorolla abandoned after 1900, provided the artist with his first major successes in Spain. In 1892, *Another Margarita* (p. 27) obtained a first-class medal

1. A 19th-century Spanish literary and painting genre of local customs and manners (translator's note).

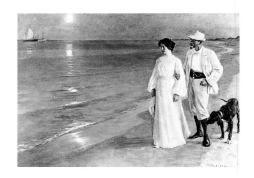

at the National Exhibition and, three years later, further triumph came with *Yet They Say Fish Is Expensive!* (p. 28), which was acquired by the Museo de Arte Moderno de Madrid. *Sad Inheritance* (p. 31) brought this chapter in the work of Sorolla to a close in 1899 and caused a sensation at the 1900 Paris World Exhibition, thereby marking the beginning of his international reputation. The influence of novelist Vicente Blasco Ibáñez and the nucleus of Valencian republican politicians and intellectuals that formed around him has often been pointed out in Sorolla's leaning towards this kind of themes. His personal relationship with the writer—who invariably provided him with enthusiastic support—and other members of his circle, such as Dr. Simarró, whom he painted working at his laboratory in the collective portrait Conducting Research from 1897, is common knowledge. However, social comment was always somewhat alien to Sorolla's artistic interests, and in these large-format canvases what predominates is the pathetic, emotive note characteristic of 19th-century genre painting.

The costumbrista vein, on the other hand, would have greater continuity, and in the paintings of Valencian fishermen from the 1890s Sorolla forged the painterly idiom that would have made him world famous by the turn of the century. These paintings to a certain extent share the explicit regenerationism of his social painting, despite lacking in its rather rhetorical critical intentions. In *Meal on the Boat* (p. 30), *The Return of the Catch* (p. 32) or *Mending the Sail* (p. 34) the daily tasks of fisherfolk are depicted without any descriptive or narrative intentions, rather the artist focused on the instantaneous nature of the image and fidelity to the natural. The emotional charge is expressed not by the motif as such but rather by its conduct in the open air beneath the intense light of the Mediterranean coast.

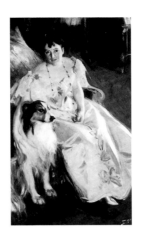

Anders Zorn, *Mrs. Walter Rathbone Bacon*. Besides their artistic affinities and common devotion to Velázquez, the Swedish painter Zorn and Sorolla shared a long friendship and mutual admiration, as revealed by the correspondence they exchanged.

In these paintings Sorolla established the main traits of his pictorial system: preference for large formats—unlike the Impressionists, who preferred the easel for these kinds of scenes painted in the open air—; descriptive synthesis rather than the minute detail that prevailed in his previous work; prominence of the human figure—invariably in small groups—that occupies much of the surface of the canvas and serves as a point of reference for the frame, oblique and very close, and seen from above, in which the lesson of photography is very much present. A major role is played in this system by fluent execution, with generous use of glaze at first and later with increasing individualisation of the brush stroke to capture the effects of light on figures and objects. Everything was oriented towards rendering invariably bright and blinding light.

It was thanks to these canvases that Sorolla gained international recognition: the same year that *Yet They Say Fish is Expensive!* triumphed in Madrid the Musée du Luxembourg in Paris acquired *The Return of the Catch,* a key work in the artist's development, as he would later acknowledge. In 1900, at the Paris World Exhibition—where he was awarded the Grand Prix by the Spanish and Portuguese pavilions, a prize of the same category as those obtained by Zorn, Klimt and Lembach—the most outstanding painting was *Sad Inheritance*, a social theme that, nonetheless, anticipates many elements of the subsequent beach scenes. His definitive triumph came in 1906 with the anthological exhibition at the Galerie Georges Petit—over which most Paris critics enthused—, those at Berlin, Düsseldorf and Cologne in 1907—which, though he sold few paintings, contributed to spread and consolidate his fame—, the show the following year at the Grafton Galleries of London—spectacularly publicised and, partially as a result of this, somewhat panned by the critics—, and, above all, with the major exhibition that

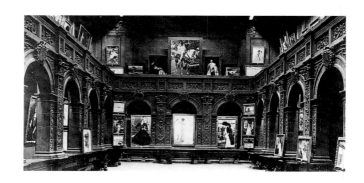

Archer M. Huntington organised at the Hispanic Society of
New York in 1909, which subsequently travelled to Buffalo and
Boston, and constituted an unprecedented event on the American
art scene.

SOROLLA'S PICTORIAL SYSTEM: LUMINISMO

Therefore between 1900 and 1911, the year when the artist returned
to the United States to exhibit with renewed success at Chicago and
St. Louis, Sorolla reached the zenith of his international fame while
at the same time consolidated the pictorial system he had been
developing during the previous decade. It is by no means gratuitous to
refer to Sorolla's artistic programme as a system, since it went beyond
the mere creation of a personal style: it embraces a whole concept
of painting that materialises through recurrent elements. It is no
coincidence that the reduction of this system to a formula would give
rise to the so-called Sorollismo by some of his Valencian imitators of
lesser stature. Sorolla himself enunciated the systematic nature of
his painting in a famous declaration of 1913, in which he limited the
gestation process of his artistic maturity to a period of twenty years:
"Until I painted the canvas that hangs at the Luxembourg [*The Return
of the Catch,* 1894] I had not perceived the ideal I was pursuing
in all its plenitude. It was a laborious, though methodical, process
of gestation. My doubts and hesitations came to find a fixed rule,
yet not suddenly, not without gradations: the process began
in Assisi [where he lived for a number of years during his Italian
sojourn], took form in my canvas *The Boulevard* [1890], became
almost completely defined in *Another Margarita* and became real,
palpable and resolved in the oxen pulling the boat in *Afternoon
Sun* [1903; p. 39]".

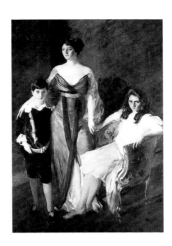

However, it would be in the canvases painted on the beaches of
Jávea and El Cabañal in Valencia or in Biarritz and San Sebastián,
between 1903 and 1912, that the system became fully developed.
Here Sorolla discovered a new dimension for large formats, which
had never before been associated with plein-air painting. The high,
very close viewpoint eliminates the illusion of depth in such a way
that all the elements of the picture appear to be on the same plane.
The spatial limits are provided by the behaviour of the light and
motifs are arranged in hierarchical order by means of resources that
once again derive from photography, such as the fact that parts of
the scene are in or out of focus, or the sudden contrast of scales.
The picturesque notes characteristic of genre painting—still present
in the canvases from the 1890s—disappear and the painter's
technique becomes increasingly flowing, with long, "splintered" brush
strokes that relate him to all the modern painters who reviewed the
lessons of Velázquez in a new light.

Light is the sole theme of these canvases, invariably in a range of pale
tones, in which sunshades, pieces of cloth, gauze and veils frequently
appear to act as disseminators, distributing and tempering the light
over the painted surface. It is no coincidence that the term Luminismo
was coined to generically describe his mature painting.

It seems unlikely that Sorolla would have managed to develop and
establish his pictorial conception not for the new scenario created
by the Paris Impressionists in the last quarter of the 19th century,
although his objectives and immediate references were very different
from theirs. The Impressionists were interested in light as an element
that makes up perception, that is, they based their painting on the
idea that we see objects because they absorb or reflect light, and
in their canvases they attempted to give visual form to the sensation

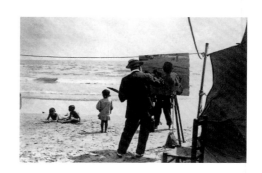

of colour that this phenomenon immediately and objectively produces on our retina. Sorolla understood light not as an object but as a spectacle, like energy that, in certain circumstances, converts nature and figures into overwhelming instances of vitality. Light is the instrument through which the Impressionists offer us an entirely new analysis and pictorial register of perception, imbued with the positivist spirit, while for Sorolla painting is an exultant celebration of light that, although it uses many of the new pictorial resources of the Impressionists, moves on an ideal and emotive plane closer to more traditional approaches. The comments by a Spanish painter very closely linked to the Impressionists—and a radical critic of the work of Sorolla—, Darío de Regoyos, is enlightening in this respect. Referring to the New York exhibition of 1909, Regoyos wrote that "it produces the same effect as contemplating an album of postcards". Sorolla "invariably [paints] the same thing, the inaississable quality of nature, boys and girls running on beaches beneath a scorching sun. As if this could be painted, as if this were an object of art! And, needless to say, everything very well defined by his fingers! In short, a swindle". Regoyos finishes his commentary by asserting his interest in light in painting, although "I am never seduced by the brutal, the inaississable, but by harmony of that same light that may always be harmonised both in the sunlight and in darkness".

CASTICISMO[2] AND COSMOPOLITANISM

Born also from this intermediate position was the critical controversy in which Sorolla was involved at the height of his fame, especially in Spain. He was frequently accused by Regoyos and others, who were closer to avant-garde stances, of being a complacent painter oriented exclusively towards the market, as he also was by writers and intellectuals of the 1898 Generation, who championed a

2. Adhering to purely Spanish values.

critically committed casticista painting more deeply rooted in national essences. These pointed towards Zuloaga as the model contrary to the fin-de-siècle, Mediterranean, vitalist cosmopolitanism of Sorolla, whom they saw as the painter of superficial appearances.

This opposition was reinforced by the commission that the potentate and champion of Spanish culture in the United States, Archer M. Huntington, passed to Sorolla in 1911. Huntington, who had met the painter in London in 1907 and had organised the major New York exhibition of 1909, signed a contract with him by which Sorolla would paint a gigantic frieze seventy metres long by almost four high for the Hispanic Society of New York, which would provide a representative view of the different regions of Spain. Sorolla had never yet faced the challenge of decorative painting, but true to his convictions he prepared to honour the commission with a series of large naturalist panels painted in oils in the open air. Such a gargantuan task led him to travel tirelessly all over Spain and occupied practically all his time between 1911 and 1919. Sorolla set out to "truthfully capture, clearly and without symbolism or literature, the psychology of each region. Loyal to the verism of my school, I seek to give a representative view of Spain, searching not for philosophies but for the picturesque aspects of each region. Although in my case there is no need to say so, I want to make it clear from the outset that I am far removed from the españolada". It is highly revealing that Sorolla found no kind of contradiction between his ambition to "truthfully" portray his country and, at the same time, seek "the picturesque aspects of each region". Moreover, the picturesque rendering would guarantee the portrait of the psychology of each region and would be an infallible vaccine against the españolada, which he evidently identified with the dramatic, truculent canvases of Zuloaga. His *Visions of Spain*, as this formidable

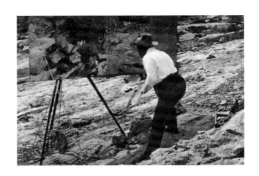

work is commonly known, is indeed an unprecedented decorative monumentalisation of the picturesque quality of 19th-century genre painting.

The gruelling effort required to fulfil Huntington's commission almost paralysed the development of the rest of Sorolla's oeuvre during that period, and his health seriously deteriorated. Having shelved the project in 1919, he hardly had enough time left to continue painting in the garden of the Madrid house he had built at the beginning of the second decade of the 20th century, where—like Monet in Giverny—he manufactured nature in keeping with his painterly needs and today, since the house was converted into a museum in 1932, it is possible to admire the most complete collection of his works there. In 1920 he suffered from the stroke that put an end to his artistic career. Sorolla died three years later.

THE CROSSROADS AT THE END OF THE CENTURY: THE "FIAT LUX" PAINTERS

The apparent contradictions in Sorolla's work are only such if we view it from the paradigm of the avant-garde, from which the artist remained deliberately aloof. He understood modernity as a profound renovation that made no break away from the pictorial tradition, as did Manet and, in their way, other contemporaries of him with whom he maintained personal and artistic links. The diagnosis by the painter and critic Aureliano de Beruete, a friend and defender of Sorolla's, made back in 1903 in reference to the work of Zorn, continues to be clarifying and may be applied literally to the oeuvre of the Valencian painter: "The painting school today called modern [...] has obtained with the artists of the fiat lux a precise, specific form [...]. The French appropriate for themselves all the glory of this quick step through three movements (Realism, Naturalism and Impressionism), and the

foundation of the current burgeoning of the pictorial art. Indeed, we owe much to the French [...], but there is something more in modern art [...], namely the element contributed to all the old schools by the artists of the young nations of the north [...]. All these painters have trained in the contemplation of nature and in the study of the works of the old masters, although they are uninfluenced by any specific artistic tradition or school".

Sorolla relied on light like no other painter of his time. It may be for this reason that—in solid alliance with his astonishing technique—his canvases continue to exert all their sensual fascination, their permanent invitation to boundlessly enjoy the most immediate pleasures of painting. The singular hybrid combination of traditional and modern traits that characterises his painting is no longer so disconcerting, now that the avant-garde has ceased to be viewed as the only legitimate source of modernity, and especially when considered in its own context: the crossroads of art at the turn of the century, when it was already possible to detect the imminence of change, although it was not yet possible to intuitively perceive its radicality and sudden acceleration after World War I.

SELECTED BIOGRAPHY

1863 Joaquín Sorolla y Bastida is born in Valencia, the elder child of the retailer Joaquín Sorolla Gascón and his wife, Concha Bastida Prat. The following year Concha, his only sister, is born.

1865 His parents die, victims apparently of cholera, and the children are adopted by Isabel Bastida, their mother's sister, and her husband, locksmith José Piqueres.

1877 Initial artistic training at the evening drawing classes, imparted by sculptor Cayetano Capuz at the Escuela de Artesanos de Valencia.

1878 Sorolla enrols at the Escuela de Bellas Artes de San Carlos in Valencia (where he stays until 1881), while serving as an apprentice locksmith at his uncle's workshop. He meets photographer Antonio García Pérez, who allows him to work in his studio.

1881 Having been awarded medals at painting competitions in Valencia the two previous years, Sorolla sends his first dispatch (three seascapes) to the Madrid National Exhibition. This year and the following he travels on two occasions to the capital, visits the Prado Museum and paints copies of the great Spanish masters of the 17th century.

1883 *Nun at Prayer* is awarded a gold medal at the Regional Exhibition of Valencia.

1884 Second-class medal at the National Exhibition for *May 2nd*. The Diputación Provincial de Valencia (Valencia Provincial Council) awards him a three-year scholarship to study at the Spanish Academy in Rome.

1885-1889 Lives in Rome and Assisi, although he returns twice to Valencia (on one of the two occasions in 1888, to marry Clotilde García del Castillo, daughter of the photographer Antonio García). He also spends the spring and summer of 1885 in Paris, where he visits the anthological exhibitions of Jules Bastien-Lepage and Adolf von Menzel.

1890 He settles in Madrid with Clotilde and obtains a second-class medal at the National Exhibition for *Paris Boulevard*. His daughter María is born.

1892 First international award (second-class gold medal at the Munich International Exhibition for *Rogation in Burgos*) and first major success at the Madrid National Exhibition (first-class medal for *Another Margarita*). His son Joaquín is born.

1893 Medal at the Paris Salon and first prize at the Chicago International Exhibition, where Charles Nagel purchases *Another Margarita*.

1894 Second gold medal at the Vienna Inter-national Exhibition. Moves into a larger studio on Pasaje de la Alhambra, Madrid.

1895 The Luxembourg Museum, Paris, pur-chases *The Return of the Catch*, which had been awarded a medal at the Salon. The Madrid Museum of Modern Art purchases *Yet They Say Fish Is Expensive!*, which had also been awarded a prize at the National Exhibition. Exhibits at the I Venice Biennial. His daughter Elena is born.

1896-1899 Exhibits regularly at the Paris Salon (almost uninterruptedly until 1906) and at the Madrid National Exhibition. The Berlin National Gallery purchases *Valencian Fishermen*, which had been awarded a prize at the city's 1896 National Exhibition. International recognition of his work is further consolidated by awards at the international exhibitions in Munich (1897) and Vienna (1898), and at the Venice Biennial (1897).

1900 The Grand Prix of the Spanish and Portuguese pavilions at the Paris World Exhibition marks his definitive recognition both in Spain and worldwide. Meets the American painter John Singer Sargent and makes contact with Scandinavian painters like Anders Zorn and P. S. Krøyer. The following year he is

awarded the medal of honour at the Madrid National Exhibition, and during the first years of the century he continues to exhibit regularly in the major European capitals.

1906 One-man show at the Galerie Georges Petit, Paris, which further strengthens the reputation he acquired at the 1900 World Exhibition.

1907 Eduard Schulte organises a series of one-man Sorolla exhibitions in Germany (Berlin, Düsseldorf and Cologne), which prove to be relatively unsuccessful.

1908 One-man exhibition at the Grafton Galleries, London, preceded by an extravagant publicity campaign that turns the critics against him. In London he meets Archer M. Huntington. He begins to paint the gardens of the Reales Alcázares, Seville, a theme of great importance in his later work.

1909 The major one-man exhibition organised by Huntington at the Hispanic Society of New York is of a resounding success. Sorolla spends five months in the United States, where he paints the portrait of President Taft. The exhibition subsequently travels to the Allbright Knox Museum, Buffalo, and the Copley Society, Boston, thereby laying the foundations for the painter's great forthcoming prestige in the country.

1910 Sorolla's work is shown at several places in Europe and America (Mexico, Santiago de Chile, Pittsburgh and Madrid). He paints the portraits of major Spanish cultural figures for the Hispanic Society, a historical work for Thomas Fortune Ryan (*Christopher Columbus Sailing from the Port of Palos*), several family portraits, and landscapes on the Basque coast. Work begins on his house on Paseo de Martínez Campos in Madrid. Sorolla's career is now at its zenith.

1911 A second sojourn in the United States and new, highly successful, exhibitions at the Art Institute of Chicago and the City Art Museum of St. Louis. He exhibits 85 works at the Hall of Honour of the Rome International Exhibition. In Paris, he signs a contract with Huntington to paint the panels for the Hispanic Society of New York, his main occupation until 1919, which will oblige him to travel continually throughout Spain. He moves with his family into the house on Paseo de Martínez Campos.

1913 He finishes the first panel of the Huntington commission, devoted to Castile and León.

1914 Sorolla works intensively on the panels for New York (this year he paints five). He is elected member of the Real Academia de Bellas Artes de San Fernando, Madrid.

1915-1919 He continues to travel and work on the panels for the Hispanic Society. In the summer of 1916 he takes a break in Valencia, where he paints some of his most important beach scenes, like *The Pink Wrap* and *Children on the Beach*. In 1917 his first grandson is born, and in 1918 his father-in-law, the photographer Antonio García, dies. On June 29 1919 he finishes *The Tunny Catch. Ayamonte,* the last panel for *Visions of Spain*.

1920 He paints portraits and garden scenes in Madrid. In June a stroke puts an end to his painting career.

1923 Sorolla dies in Cercedilla, in the mountains near Madrid, on August 10, and is buried in his native Valencia. The room of the Hispanic Society where the *Vision of Spain* panels are eventually installed is not inaugurated until January 1926.

THE FORMATIVE YEARS

Between 1881, when Sorolla completed his studies, and 1890, when he settled in Madrid after his return from Italy, the artist's work adjusted to the canons established by a young painter who was setting off on a career marked by orthodoxy. He would therefore paint historical and genre canvases like those exhibited at the official exhibitions in all European countries. However, his technical gifts, his passion for colour, and his rendering of scenes in the open air conditioned his way of approaching these genres. At this time Sorolla was still seeking his own artistic path, but the influences that may be detected in his early work (Fortuny and the colourists of the contemporary Valencian School) were already indicative of the direction his work would take as from 1890. Lastly, it is important to note two milestones in his career at the time: his visits to Madrid in 1881 and 1882, during which he steadfastly copied Velázquez and the Spanish masters of the 17th century at the Prado Museum, and his sojourn in Paris, which coincided with the anthological exhibitions of Bastien-Lepage and von Menzel.

FATHER JOFRÉ PROTECTING A MADMAN. 1887. Father Jofré is a historical theme stipulated by the Diputación (Provincial Council) of Valencia as the last of the paintings required to justify his Rome scholarship. A Valencian Mercedarian friar of the 15th century, he confronts a group of youths who are stoning a madman. Later this same friar would find the world's first lunatic asylum in Valencia.
The theme is therefore a moralising one, in which there is something of the compassionate, regenerationist vein of Sorolla's subsequent social paintings.

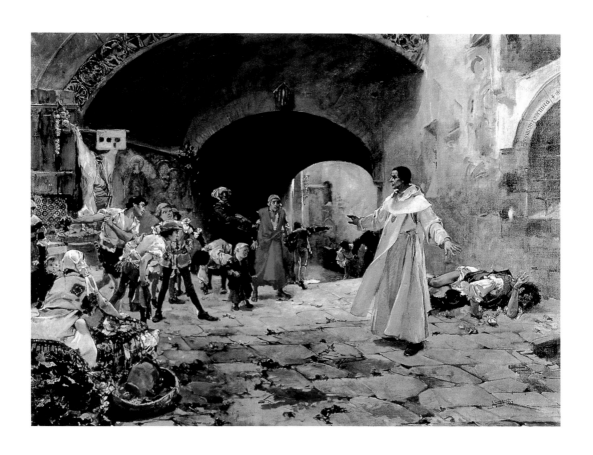

BACCHANTE. 1886; HEAD OF ITALIAN GIRL. 1886. These two small-format studies, executed by Sorolla while being a scholarship-holder in Rome, reveal his clear leanings towards the most pictorial and colourist options available to a young painter undergoing his academic training. The obvious reference to Velázquez in *Bacchante*, whose posture recalls that of *Venus in the Mirror*, reveals one of Sorolla's recurrent influences, and the dedication to Emilio Sala—a Valencian painter whom he greatly admired and whose pupil he had been at the Academy in Rome—attest to the influence of the colourism predominant in the Valencian artistic ambience of those years.

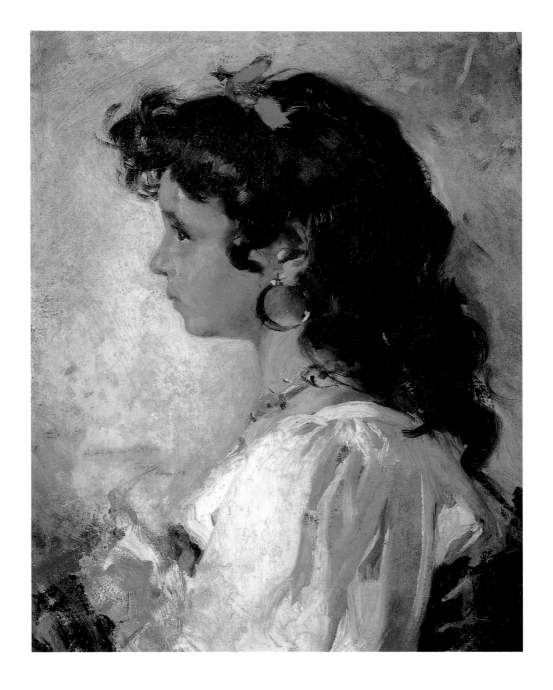

SOCIAL REALISM

Sorolla's first personal artistic principle was fidelity to the natural, which he would obey throughout his career, although invariably oriented towards comment on Spanish social reality from a critical, regenerationist viewpoint. The influence of the circle of his fellow-Valencian Blasco Ibáñez—who like Sorolla also enjoyed international fame and, like the artist, easily made the transfer from Valencianismo to cosmopolitanism—was, it seems, decisive in this option, although regenerationist social painting was a relatively widespread phenomenon in Spanish painting of the time in the persons of Casas, Zuloaga and Joaquim Mir. Sorolla sought a modern alternative to old historical painting and, in his quest, the artist attempted to endow a number of common conventions in both this and costumbrista painting with new meaning. Sad Inheritance brought this cycle to a close in 1899, since it was not the possibilities of narrative and social commentary of realism that interested Sorolla. Even so, it is possible to detect in these paintings the first recognisable signs of some of the elements characteristic of his mature painting.

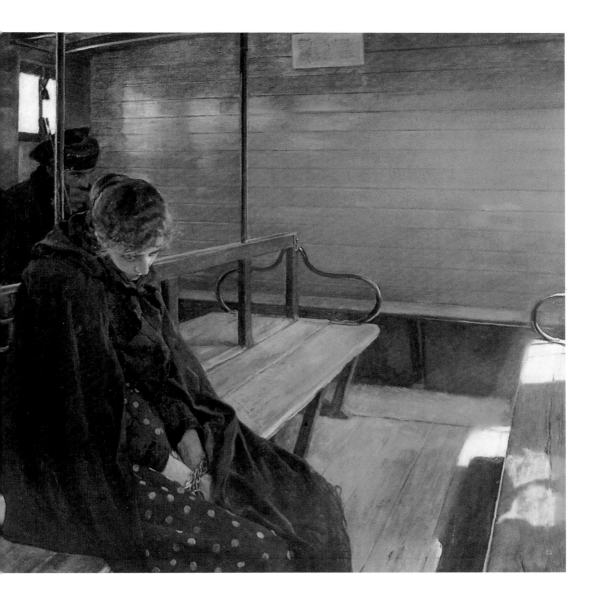

ANOTHER MARGARITA. 1892.
Another Margarita was the first
of Sorolla's major paintings
to be exhibited in the United
States. The tragedy of this
woman—arrested for having
suffocated her little son
and inspired, apparently, in a
scene that the painter himself
witnessed during a train

journey—is expressively
recreated in her foreshortened
figure, which the diagonal view
of the carriage, in deliberate
contrast to the position of the
benches, seems to accentuate.
The austere carriage, and the
gloomy quality of the woman and
her guards, contrast, in turn,
with the warm, tempered light

that enters through the windows
and bathes the entire space,
introducing a melancholy note.
This treatment of light would
lead Sorolla to regard this
canvas marking as one of
the decisive steps towards
the construction of his
painterly system.

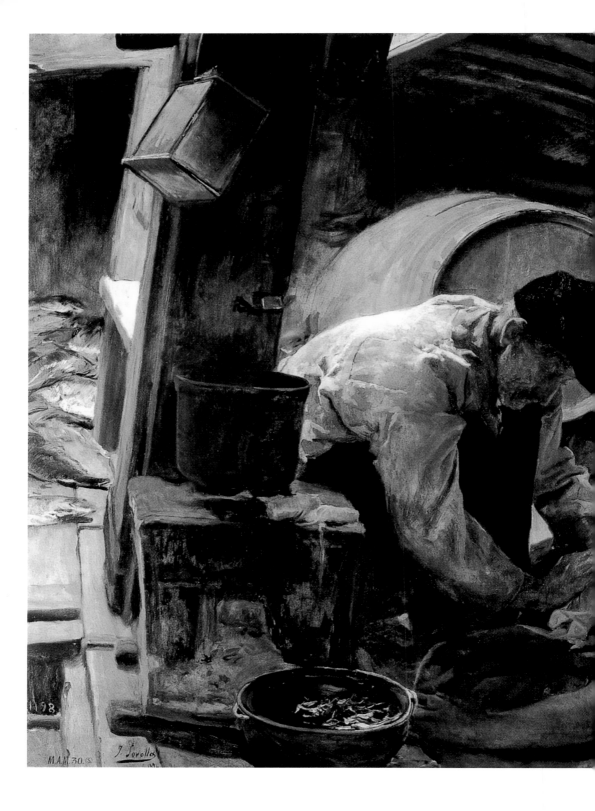

M.A.M 30.(S) J Sorolla

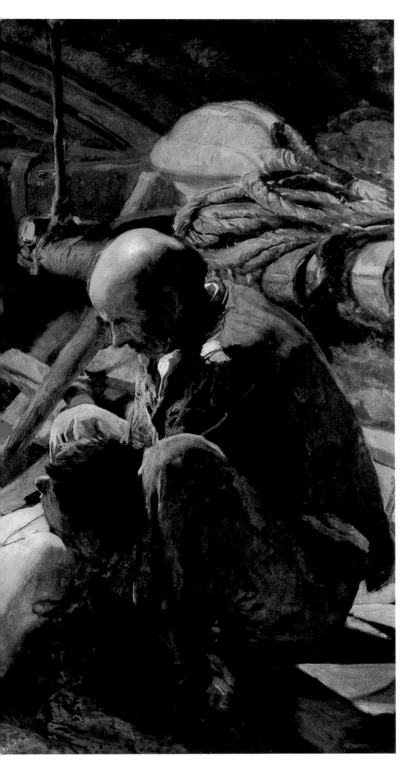

YET THEY SAY FISH IS EXPENSIVE!
1894. The scene featuring the
two fishermen attending to
their companion, caught by a
hook, is also set in an unstable
space, here a rocking boat,
although the approach here
is more traditional, with the
contrasting diagonal light
characteristic of 17th-century
naturalist painting. Although
the formats and moralising
tone of both canvases seek to
emulate, from a modern point of
view, the dignity of historical
painting, the pathetic register
of the titles and of the mise-
en-scène evoke some of the key
qualities of genre painting.

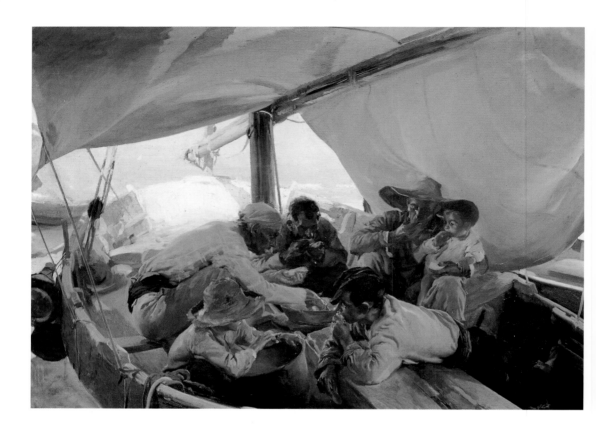

MEAL ON THE BOAT 1898;
SAD INHERITANCE, 1899.
The social realism of these
canvases is combined with a
clear vocation for research.
In the first, Sorolla contrasts
the treatment of the group
eating in the shade of the sail
with the prow of the boat,
the forms of which are entirely
dissolved into the light. This
contrast guarantees the
sensation of relief and volume
in the area sheltered by the
canvas, while the rest is a
fragment of completely free
luminist painting with an
against-the-light effect
that might well be related
to photography.
Sad Inheritance is the most
elaborate of these works of
social content (the children are
crippled as the outcome of their
parents' syphilis, hence the
title). This painting took the
1900 Paris World Exhibition by
storm, after which the artist

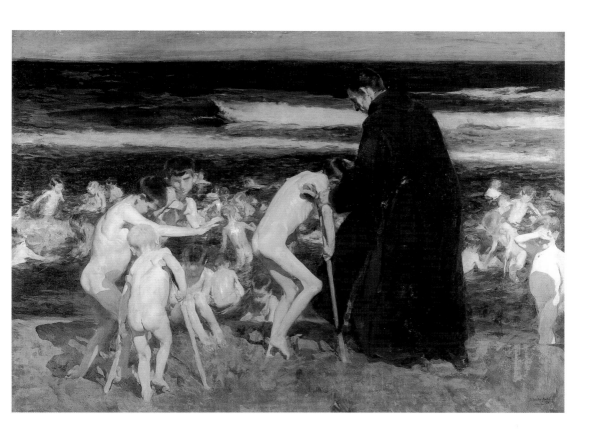

would never return to this
particular genre. Although this
is clearly a studio painting,
the framing and the way the
groups of children further
in the background are treated
herald some of the elements
that would later reappear in the
beach scenes. This relationship
appears even more clearly in
some of the preliminary
sketches, which conserve the
immediacy of open-air painting.

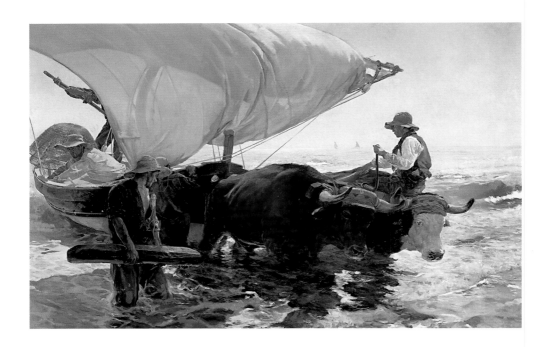

THE REALISM OF LIGHT

Sorolla's success in Paris in 1900, more than confirmed six years later at the Galerie Georges Petit, signalled the beginning of the most brilliant stage in the artist's career, and the discovery of his personal style as a painter. The fact that he met in the French capital the Swedish painter Anders Zorn, with whom he maintained a long friendship and whose work he extolled on several occasions, would have played an important role here. Parallel to his canvases of social content, Sorolla had been developing a kind of costumbrismo that focused on the life of Valencian fishermen, in which anecdote tended to diminish in favour of an ever increasingly bold rendering of the effects of the dazzling light of the Mediterranean on objects and figures. By 1903 the costumbrista connotation had disappeared and his canvases became great fields of diluted or concentrated colour that completely dissolve form in light, especially those painted on the beaches of Jávea and El Cabañal. Once he had found his register, Sorolla would not abandon it and, as the years went by, his beach paintings became increasingly carefree and flowing.

THE RETURN OF THE CATCH. 1894; VALENCIAN FISHWIVES. 1903. These may be the first two paintings in which Sorolla's pictorial system appears fully recognisable for the first time. The execution is somewhat rough compared to that of subsequent works, although the vibration of the light captured in the open air takes precedence over generic conventions. The raised

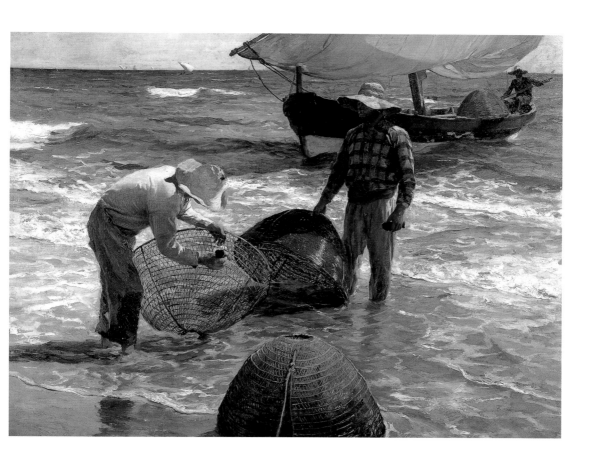

viewpoint brings us straight down onto the water near the beach, while the sail serves in both cases as a light condenser and diffuser. Furthermore, *The Return of the Catch* already applies the large format to this kind of scenes, another characteristic trait of Sorolla's mature work. As the artist himself said, this canvas was the first in which he managed to give visual form to his painterly ideal, and also one of his first great international triumphs, since it was acquired by the Musée du Luxembourg after the 1895 Paris Salon. The smaller format *Valencian Fishermen*, also obtained a gold medal at the 1896 Berlin International Exhibition, and was purchased by the Nationalgalerie.

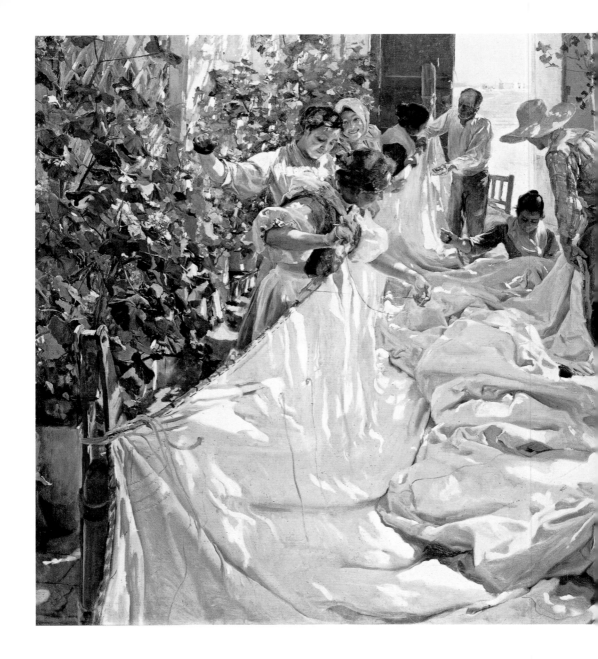

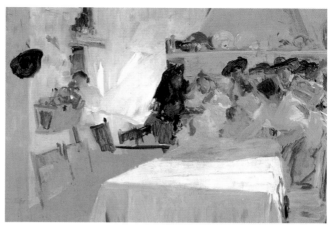

MENDING THE SAIL, 1896; THE CHRISTENING, 1899. "It is highly audacious for him that mass of formless canvas that seems to be the protagonist of the composition", wrote critic José Ramón Mélida in reference to the public's negative reaction to *Mending the Sail* at the 1899 National Exhibition, although it had been awarded prizes in both Munich and Vienna. The shreds of light on the sail, that is being darned by the women beneath a climbing vine, prevail, indeed, over what is apparently a popular, realist vignette. Sorolla's palette had by this time become fully consolidated, as was his concept of painting as the celebration of life and nature rather than as an instrument of representation and narrative. The same applies to *The Christening*, in which the light slips over the figures and the table in sketchy sweeps of the brush that leave the pictorial matter and gesture visible. For this work —which he would present as a gift to his friend Zorn— Sorolla applied the subtle contrast between shining white and the bluish violet tones of the shadows, one of his characteristic resources when it came to resolve the contrast between light and shade without the result being in detriment to luminosity.

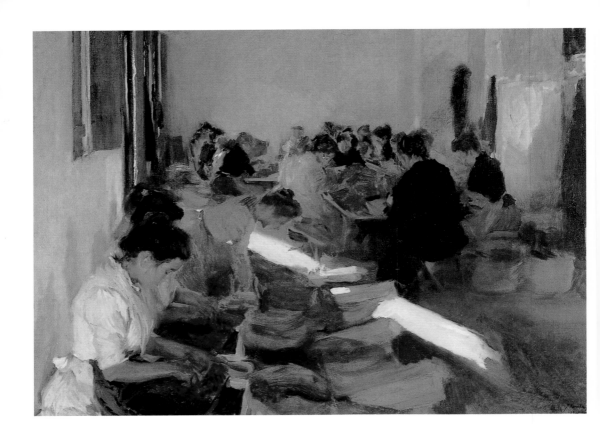

PACKING RAISINS. 1901; VALENCIAN FISHWIVES. 1903. In these two works Sorolla combines snapshot-like scenes from the life of the humble classes with a thick impasto, more highly charged with pigment than was usual in works similar in theme. In *Packing Raisins* —painted during his sojourn in Jávea in the summer of 1901— he has recourse to a spatial structure similar to that of *Mending the Sail*, which depicts a similar scene, except that here the scene is set in a gloomy interior. The beam of yellowish light that floods the room dissolves the forms in its path and endows the

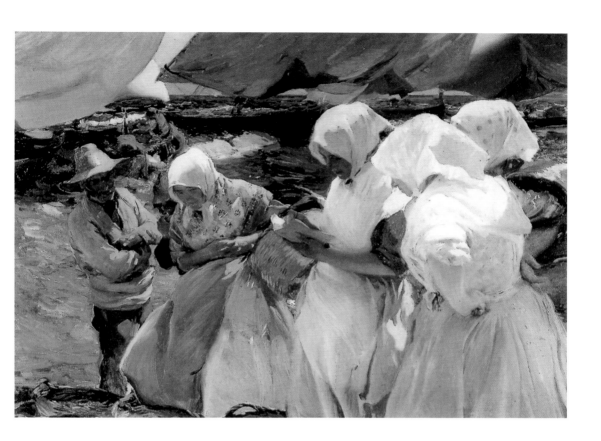

mauves, reds and browns with
warmth. In *Valencian Fishwives*
the sun moulds the forms,
thereby boldly increasing the
intensity of the tones and
endowing the figures of the
fishwives with a certain
monumentality, enhanced by
their position in close-up.

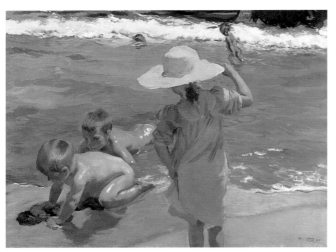

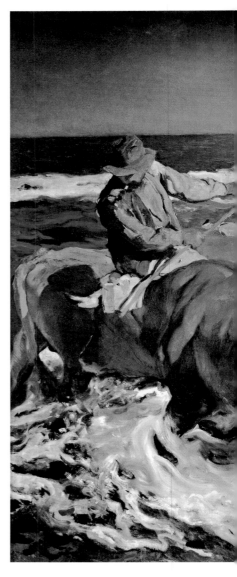

CHILDREN ON THE SEASHORE. 1903;
AFTERNOON SUN. 1903. In *Children
on the Seashore* all anecdotal
content has been entirely
eliminated. The painter focuses
on the detail of the children,
and the fragmentary nature of
the picture is accentuated by the
oxen, only barely perceived in
the top right-hand corner as
they pull the boats ashore.
The elimination of the sky
converts the space of the
painting into a sliding plane,
and the picture is transformed
into pure luminous vibration
on the little girl's hat and
the film of water on the two
boys' naked bodies. *Afternoon
Sun* presents a similar

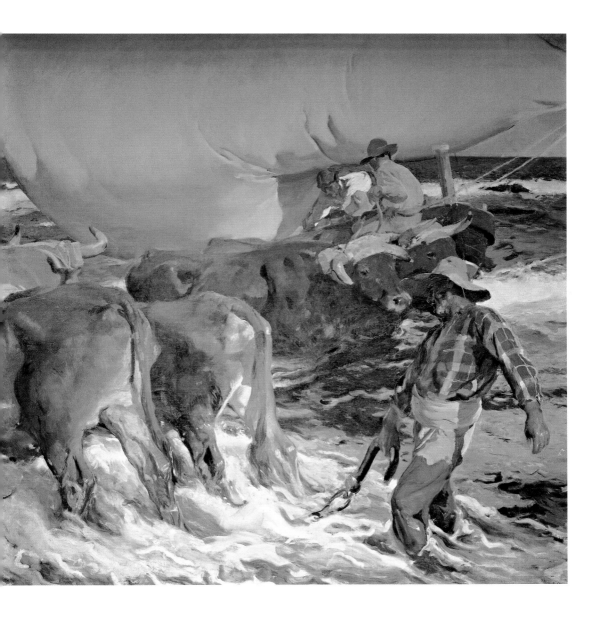

spatial solution, although the composition, the prominence of the oxen's rumps and the sail swollen by the wind are more traditional in execution. For Sorolla, this was the canvas in which he at last found the path he had been seeking from his early days, the path that would be foreshadowed nine years earlier in *The Return of the Catch*, which is almost identical in theme. Here, however, these details and the emotive connotations of the dusk light evenly bathing the scene brings the canvas closer to the genre painting of the previous century than to the mature Sorolla.

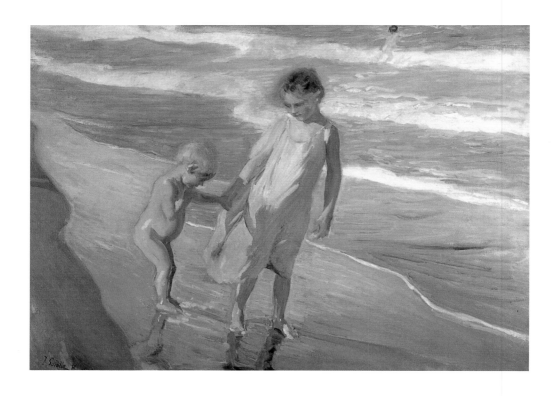

VALENCIA, TWO LITTLE GIRLS
ON A BEACH. 1904; MIDDAY ON
VALENCIA BEACH. 1904. In a
number of relatively large-
format works from this year
Sorolla began to apply solutions
that he had hitherto limited
to sketches and small format
paintings. At the same time,
his palette became considerably
lighter. The first, painted
on the Valencian beach of El

Cabañal, is a luminous symphony
of blues and whites, tempered by
mauves and greenish yellows that
complete the colour range with
brush strokes that flow over the
surface emulating the movement
of the waves and the swell of
the water on the sand. The
background seems to encroach
on the figures, constituting a
single plane of tone gradations.
In the second canvas Sorolla

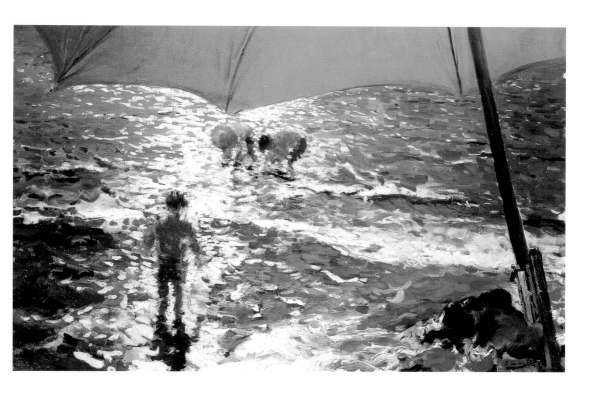

fragments his brush strokes to
create the silvery effects of
light on the choppy waters
of the sea, while the parasol
under which the painter sits,
with its flat, compact colour,
justifies the extraordinary
spatial synthesis in a highly
original interpretation of the
characteristically photographic
interplay between areas in
focus and out of focus.

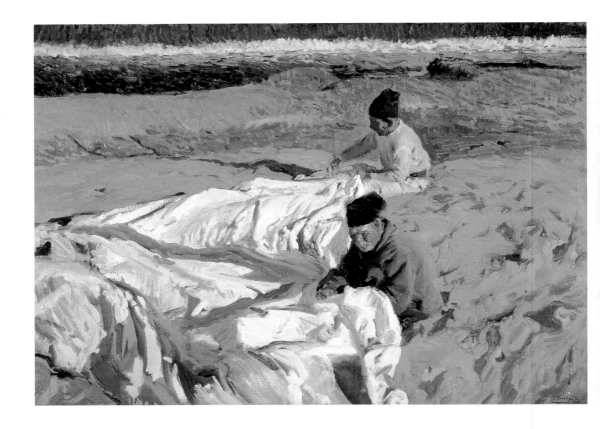

MENDING THE SAIL. 1904;
SNAPSHOT. BIARRITZ. 1906.
Sorolla's characteristically
raised, oblique viewpoint
creates in these two canvases
a pictorial space composed of
large juxtaposed colour fields
in which the figures are
modelled by fine brush strokes
of sparsely applied paint,
occasionally almost transparent.
Mending the Sail takes up the
1896 motif again, despite by now

without any hint of genre
painting (the two fishermen are
absorbed in their tasks, they do
not form a group, they exchange
no glances, and the canvas is
cut sharply by the edge of
the painting). *Snapshot* shows
Clotilde, the painter's wife, on
Biarritz beach during the summer
that followed the resounding
success of the 1906 Paris
exhibition. The motif of the
photographer surprised in her

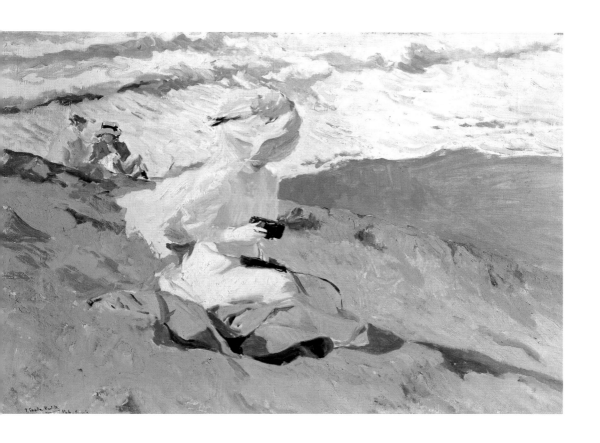

tasks by the painter is charged
with connotations: Clotilde,
the daughter of a photographer,
captured by the immediacy of
Sorolla's plein-air painting,
which allows him to render the
subtlety of Clotilde's gauze
veil melding with the foam from
the waves, as if the painter
were challenging the speed of
the camera.

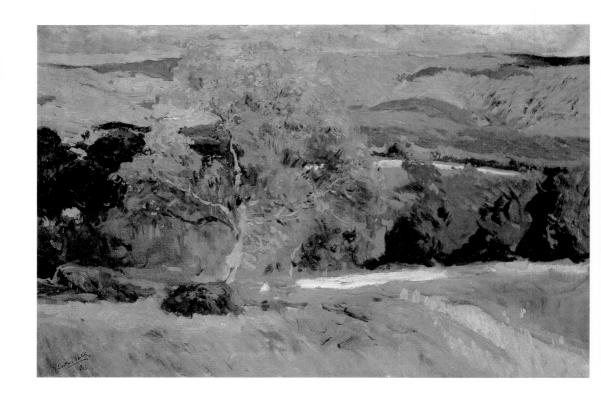

THE YELLOW TREE. LA GRANJA. 1906; VIEW OF SEGOVIA. 1906. During
these years Sorolla painted a substantial number of landscapes in
which he dispensed with his characteristic interplay between light
and figures to focus on atmospheric effects. His brush stokes became
more fragmented than those of his beach scenes, although they also
tended to group together in generous colour masses without detriment
to lightness. The influence of his friend Beruete, the most
prestigious Spanish landscape painter of the period, is clearly
visible here.

AFTER A BATHE. 1908.
After a Bathe heralds
the morbid sensuality
and extraordinary fluidity
of the beach paintings of his
mature years. The linen with
which the boy wraps the girl
acts as a panel of light
superimposed on the shimmering
waves. The immediacy of
luminista realism here produces
a paradoxical effect that
borders on decorativism.

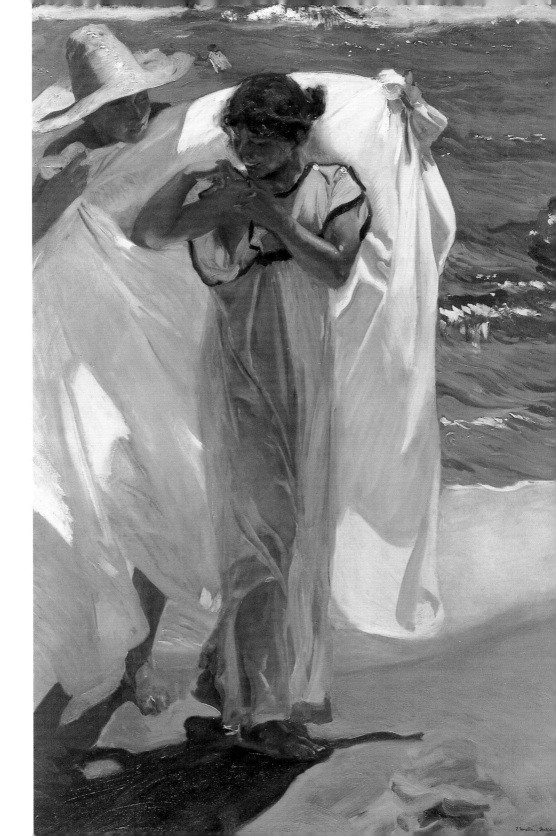

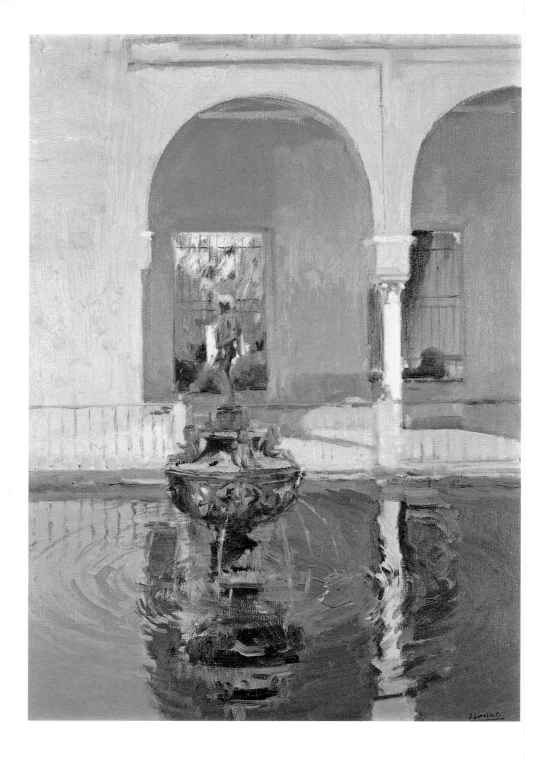

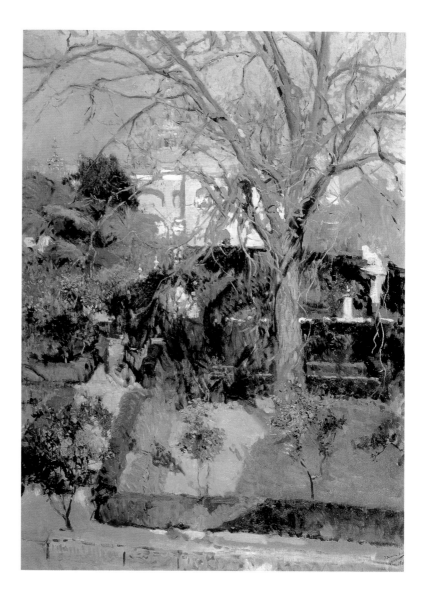

THE FOUNTAIN IN THE ALCÁZAR OF
SEVILLE. 1908; GARDENS OF THE
ALCÁZAR OF SEVILLE IN WINTERTIME.
1908. In 1908 Sorolla painted a
number of canvases in Andalusia,
outstanding among which are
views of different corners of
the Reales Alcázares. It is
interesting to compare how
in these paintings the artist
adapts his pictorial view to
light and motifs different from
those of his Valencian beach
scenes. The fragmented quality,
the long, flowing brush strokes
and the light effects, using
very fine impastos, are the
same, although here we detect a
more intimate feeling for place
that heralds the paintings he
executed in the garden of his
Madrid house during the last
years of his career. Twenty years
before, Zorn had painted similar
scenes at the Alhambra that
might be compared to these, which
in turn would have influenced
John Singer Sargent when in 1912
he painted a fountain in the
gardens of Aranjuez.

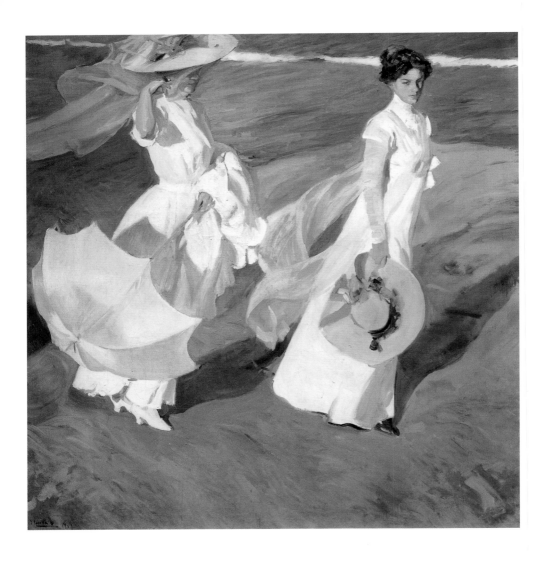

PROMENADE BESIDE THE SEA. 1909;
THE TWO SISTERS. 1909. During
the summer of 1909, after the
resounding success of the
New York exhibition, Sorolla's
luminismo reached its zenith.
Having completely eliminated the
anecdotal aspects characteristic
of genre painting in favour of a
far more concrete and fragmented
view of the motif, the painter
now took a further step forward
by breaking the barrier that

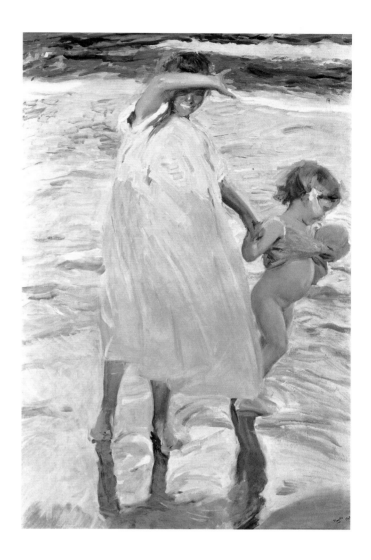

separated the notes and small,
sketchy canvases from the large-
format works. *The Two Sisters*,
indeed, seems to be a large
sketch executed with broad,
highly diluted brush strokes.
The wind that stirs the gauze
veils of the two women—the
painter's wife and their
daughter María—seems to
meld with the light. In both
canvases, the ground on which
the figures tread and the sea

in the background are unified
into a single plane in the form
of a curtain, consisting in
one case of juxtaposed colour
fields and in the other of
an astonishing gradation of
different shades of blue that,
in the area where the two girls
stand, converts the sand into
a veritable mirror that at
once absorbs and reflects
the light.

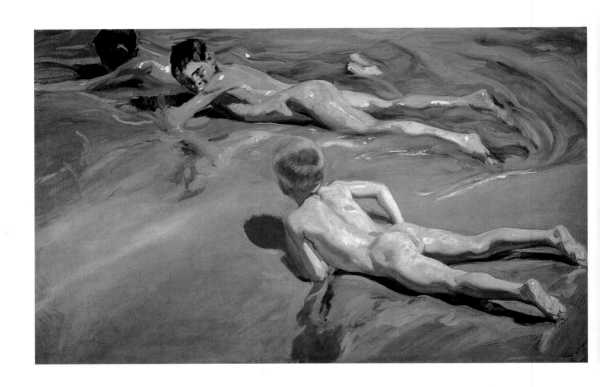

BOYS ON THE BEACH. 1910; BENEATH
THE CANOPY (ZARAUZ). 1910.
The sketchy treatment of large
format canvases reached its
zenith between 1909 and 1911.
The canvas painted on Zarauz
beach reveals an arrangement
of the figures parallel to the
plane of the painted surface,

rare in this kind of work. The
brush strokes here are also less
individualised, which creates
the impression of homogeneous
colour fields impregnated with
intense luminosity, condensed
and tempered by the parasol,
beneath which the figures are
grouped, a recourse at Sorolla

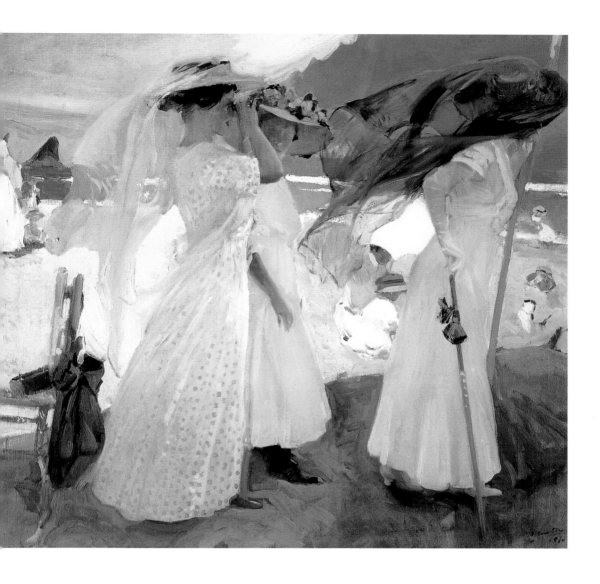

had first exploited in his early beach scenes. On the other hand, is more characteristic of the artist's sloping, shifting spatial arrangements. The touches of white create the effect of the sheen of the film of water on the wet, incandescent skin of the boys, giving rise to one of the emblematic images of Sorolla's painting. The canvas constitutes a prime example of the painter's idea of his work as the sensual celebration of the spectacle of light.

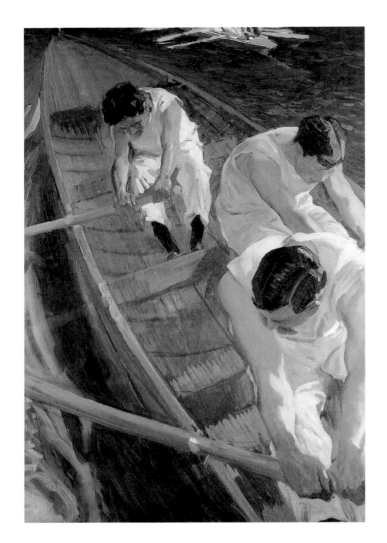

IN THE RACING SHELL (ZARAUZ).
1910; THE SIESTA. 1912. Two
canvases executed on the Basque
coast—then the summer resort for
the Spanish royal family
and for much of the haute
bourgeoisie of both Spain
and France—that reveal how
as from 1910 in his painting
Sorolla sought new innovative
directions without renouncing
to his fundamental principles.
The bird's-eye view of the
rowers—which recalls some of
Gustave Caillebotte's canvases
of similar theme—and the
fragmented frame of the motif
reveal an explicit interest
for the rendering of space and
of movement in combination with
light. Something similar occurs
in *The Siesta*, in which the
characteristic system of the
beach scenes is transferred
into a meadow in Guipúzcoa.
The broader, more compact brush
strokes of these years is
charged here with infinite
nuances, but as invariably
occurs in Sorolla's painting,
within a restricted range
of tones in counterpoint
with light, masterly touches
of red, yellow and mauve.

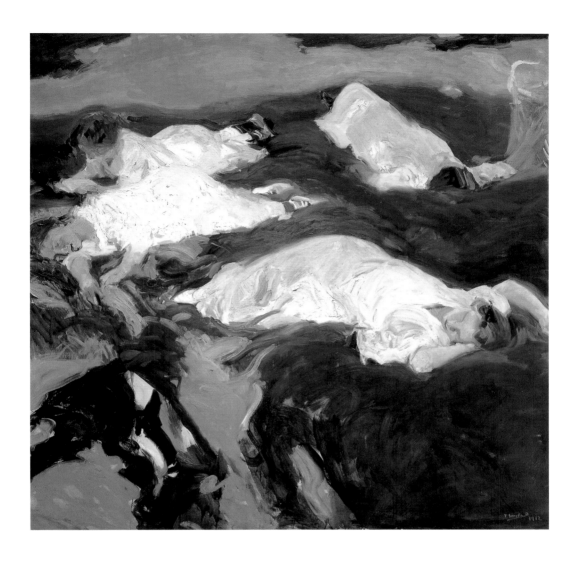

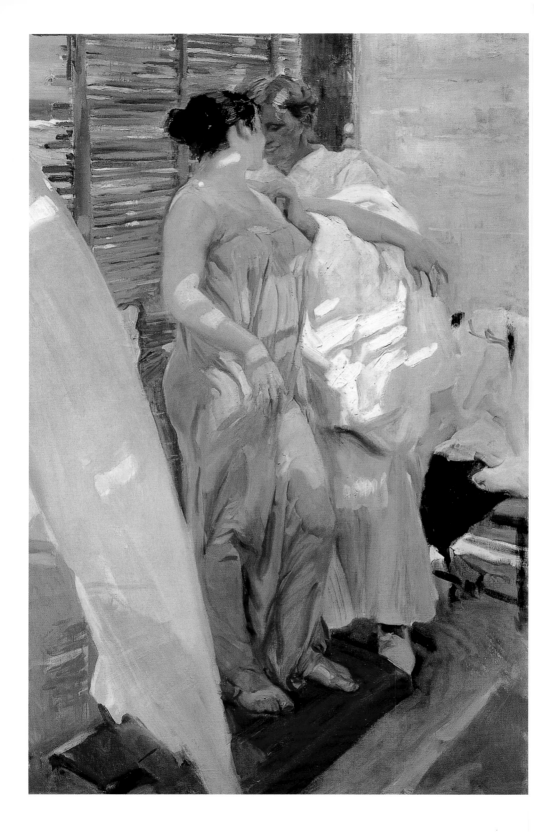

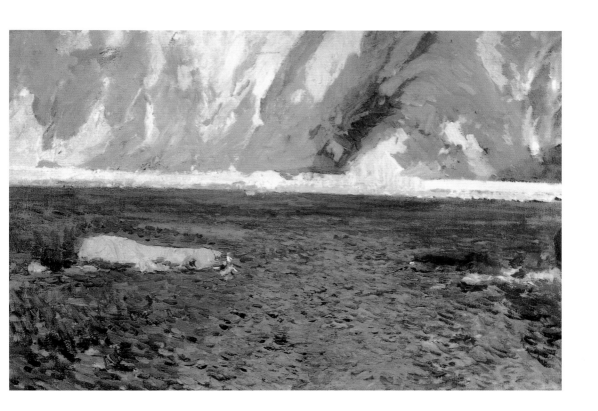

THE PINK WRAP. 1916; THE COAST
NEAR SAN SEBASTIÁN. Around 1918.
The Huntington commission took
Sorolla away from his favourite
themes between 1911 and 1919.
He was thereby forced largely
to abandon the line of research
begun with canvases such as *The
Siesta* and *Beneath the Canopy*.
Even so, in 1916 the artist took
a short break and spent the
summer in Valencia together with
his family. There he painted
a series of five large-format
canvases on the beach, in
which his luminismo reached
unprecedented heights of
fluidity and freedom. The drape
that closes the hut in which the
two women are dressing in *The
Pink Wrap*—the most famous work
from this extraordinary
series—invades the space

as it is moved by the wind,
and becomes a veritable
jet of bluish white light that
establishes a dialogue with the
whitewashed wall on the right.
The light filtering through the
slats tempers the folds of the
wraps, condensing or diluting
the pigment, and tinting the
shadows with greenish, bluish
and yellow tones. The brush
strokes are individualised while
at the same time merging into
each other with astonishing
naturalness. Similarly, the
freedom of colour and execution
of the small-format paintings
from this period, such as
The Coast Near San Sebastián,
faithfully reflects, the great
innovative potential of
Sorolla's late works.

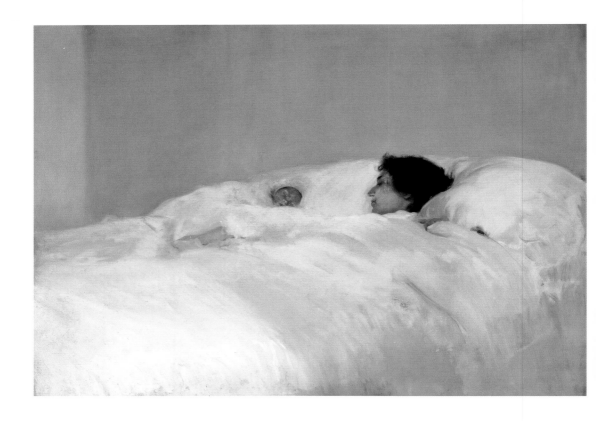

IMAGES OF INTIMACY

Sorolla combined his hectic public life as a painter of enormous success with a private life organised on the basis of deep family ties. It is not surprising that he often exploited his wife, three children and the spaces of family life as pictorial motifs. These works of a more intimate family character are also evidence of the coherence and sincerity of the artistic convictions of Sorolla, whose detractors accused him of bowing to the tastes of his abundant, well-to-do clientele. These canvases exude a characteristic warmth, and their pictorial idiom is the same as that of the paintings that triumphed in exhibitions and contests all over the world. Sorolla was not only a passionate surrender to his métier entirely sincere, but it also invaded and infected all aspects of his existence. It might well be said that rather than depicting nature in his canvases, Sorolla attempted to build a tailor environment made for his imperious need to paint and to paint in a specific way. His Madrid house, now the Museo Sorolla, which was finished in 1911, largely responded to this need, and during his last active years his garden was one of the recurrent themes in his work.

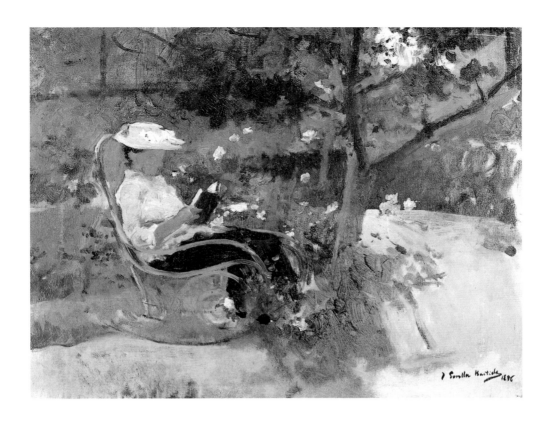

MOTHER, 1895; IN THE GARDEN,
1896. Two early family scenes
in what are uncommon registers in
Sorolla's work from this period.
In *Mother*, Clotilde looks
tenderly at Elena, the couple's
second child, enveloped in a
cottony mass of bright light.
The white is tempered
by an entire gamut of gentle
yellowish and greenish tones to
create one of the first spaces
totally configured by light
in the artist's oeuvre. Here
Sorolla comes close to modernism
and to an almost decorative
sense reminiscent of Whistler,
a painter who while not greatly
influencing the Valencian did
influence Catalan Modernistes
such as Casas and Rusiñol. The
image of Concha Sorolla, the
painter's sister, reading in
a garden reveals a fragmented
brush stroke close to the style
of the French Impressionists
that heralds the family scenes
the artist would paint in the
garden of his Madrid house
as from 1911.

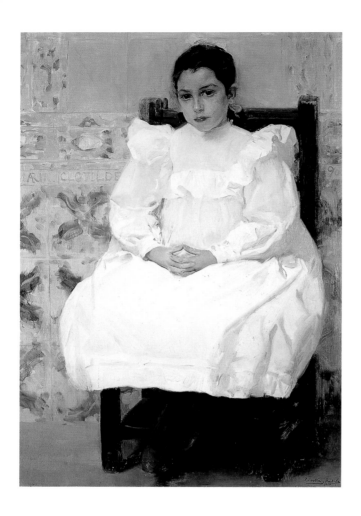

MARÍA. 1900; MY FAMILY. 1901.
The frontal image of María, the
artist's eldest daughter, before
a wall decorated with tiles,
recalls portraits by Sargent,
although the register is far
more immediate and lacks the
formal distance characteristic
of commissioned works.
The bright white of the girl's
dress, executed in broad brush
strokes, is highlighted by
touches of blue, as in *Mending
the Sail* from four years before
or in the first beach scenes
from a few years later.
The reference to Velázquez

in the family scene is obvious:
the figures emerge from a
sombre background, and the
mirror reflects the image of
Sorolla, palette in hand, in
the background. Velázquez—and
his way of painting "from inside
outwards" as Sorolla would write
years afterwards in an article
on his friend Zorn—was one of
the main points of reference
common to all artists committed
to a modern naturalism alien to
the incipient avant-garde
movement born from French
Impressionism.

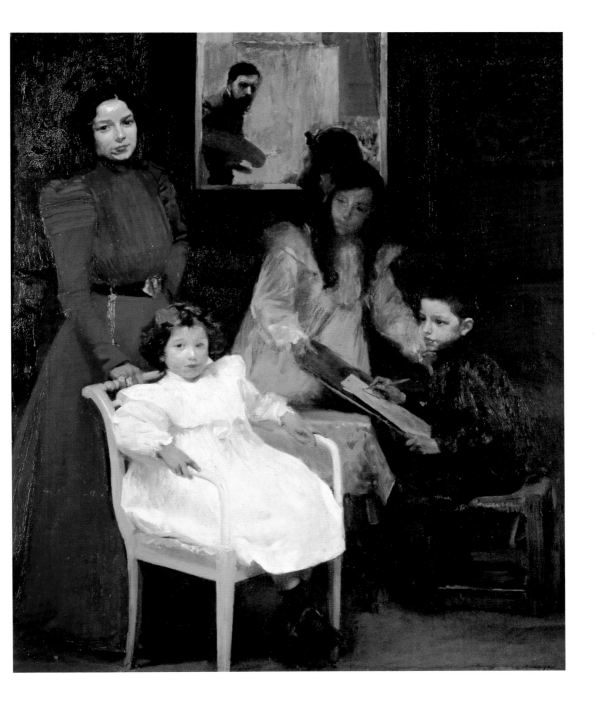

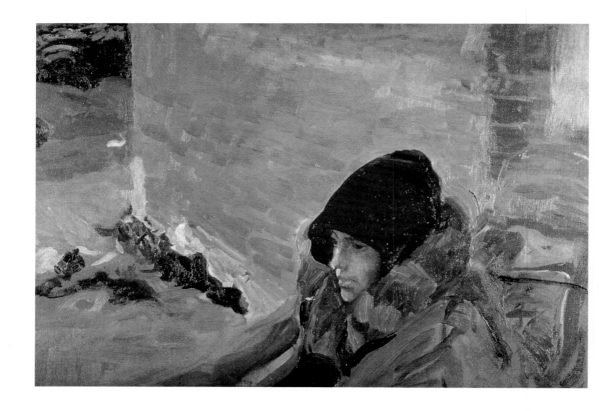

MARÍA SICK. 1907; MARÍA
PAINTING IN EL PARDO. 1907.
María Sorolla, who inherited
her father's painterly vocation,
would develop a personal style
somewhat removed from Sorolla's
naturalism. The first of these
two portraits of María shows her
in the mountains near Madrid
recovering from the illness
that prevented her father from
travelling to Germany to attend
his 1907 exhibitions in Berlin,
Düsseldorf and Cologne. Both
the sketchy technique and the
violent foreshortening are very
audacious, although this
tendency towards spatial
synthesis and relative absence of
depth is also characteristic
of the large-format beach

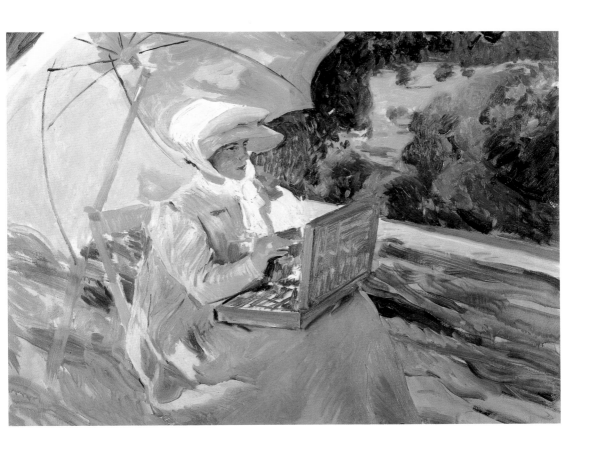

scenes. The other portrait shows
María, fully recovered by now,
painting in the open air. The
three-quarter view of the sitter
and the lack of sky transform
the background into one of those
sloping planes characteristic
of Sorolla. The sunshade that
condenses and tempers the light
is also a frequent resource
in the artist's work. The
most striking aspects of this
picture, however, are the wide,
separate brush strokes and,
above all, the extraordinarily
free treatment of colour,
an example of the quest for
innovation that marked Sorolla's
canvases from this period.

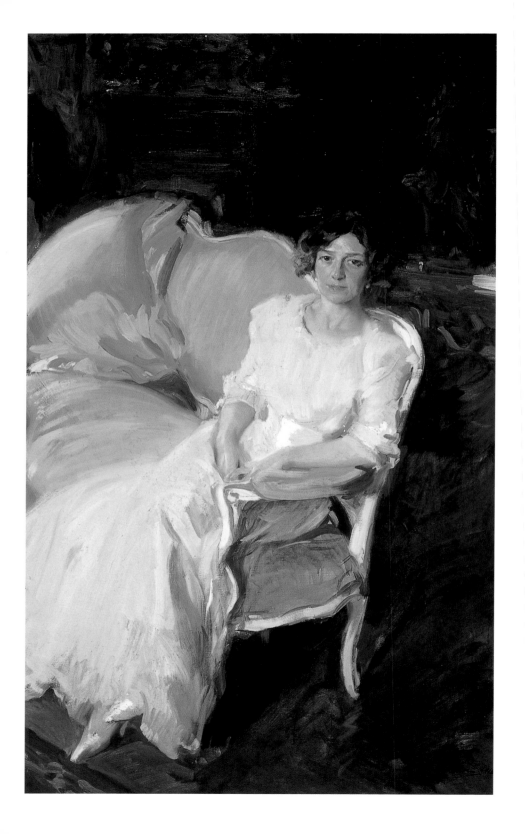

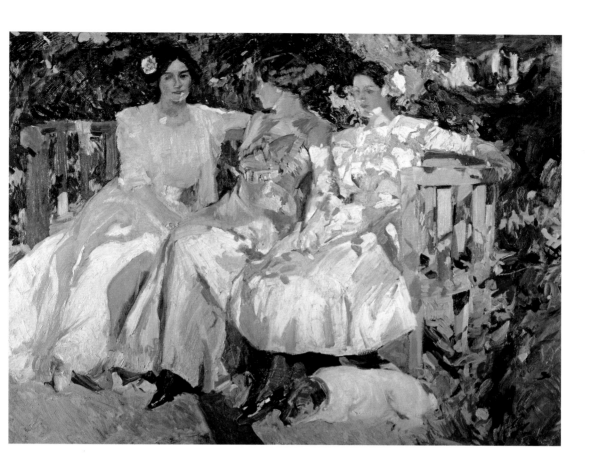

CLOTILDE SITTING ON THE SOFA.
1910; MY WIFE AND MY DAUGHTERS
IN THE GARDEN. 1910.
When painting his family,
Sorolla did not hesitate to make
full use of all the ingredients,
both innovative and closer to
tradition, that constitute his
oeuvre. The portrait of his
wife on a sofa attests to the
influence of Sargent—although
the technique and the use of
whites and yellows are Sorolla's
own—and is a further example of
the artist's tendency to
organise the space of the
composition in an unconventional
way. On the other hand, the
portrait of Clotilde, María and
Elena in the garden is among the
most advanced works of his later
years, especially if we take
its large format into account.
Sorolla declared his preference
for portraits in the open air,
although in this case the
colour and the light completely
dissolve the forms and
physiognomies of the figures
to the extent that it cannot
be regarded as a portrait
in the strict sense. Indeed,
the essence of the scene is not
different from that of much
earlier paintings, namely a
celebration of light and the
spectacle of life materialised
in visual stimuli. This was
invariably Sorolla's programme
as a painter.

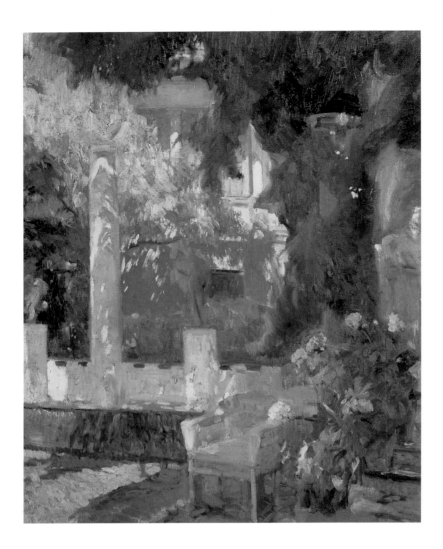

ROSE BUSH AT THE SOROLLA HOUSE.
1920; WHITE ROSES FROM THE HOUSE
GARDEN. 1919.
The garden of his house was
Sorolla's favourite subject
during his last years. This
space, conceived to be painted,
is the epitome of a luminismo
that, beyond his stylistic
evolution and the different
possibilities with which he
experimented at different
moments in his career,
synthesises the pictorial
ideal he cherished from the
early days. These invariably
fragmentary views, highly varied
in terms of kind of brush stroke
and technical resources, are not
usually very big and confirm the
free, flexible ways of relating
to form that Sorolla explored
in his last period. The garden
seems to enter the house in the
form of the flower vase—a rare
subject in Sorolla's work—, one
of the last canvases that,
apparently, he managed to finish
before he was disabled by his
stroke. The vibrant orange of
the background, reflected in the
table, is an example of the
almost arbitrary colour of some
of his last sketches and invites
the observer to wonder about the
path he would have followed had
he been able to paint for a few
years more.

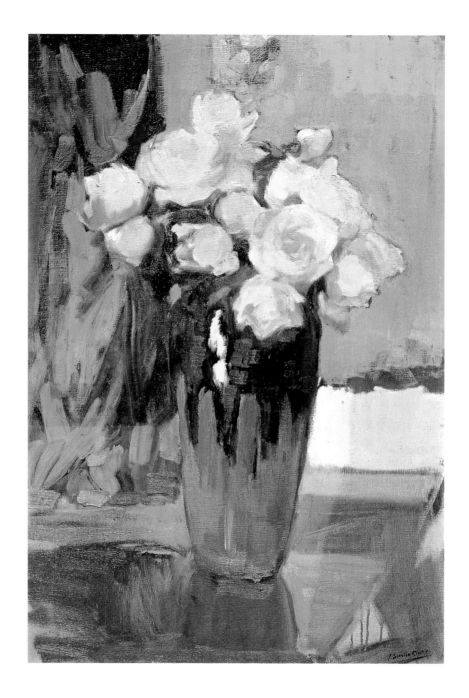

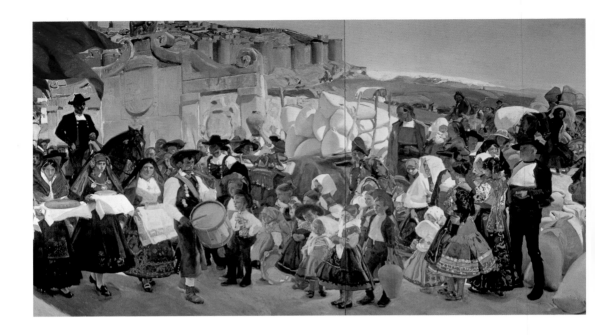

VISIONS OF SPAIN

The culmination of Sorolla's success in the United States came in
1911 when Archer Milton Huntington, founder of the Hispanic Society
of New York, commissioned him to paint a large decorative frieze for
a new hall on the institution's premises. Huntington wanted a mural
featuring milestones in the history of Spain, but Sorolla preferred
to paint a series of "renderings of contemporary life in Spain and
Portugal", although he eventually decided to restrict himself to Spain.
With neither experience of nor vocation for decorative painting, Sorolla
decided the programme into canvases of variable dimensions that
together would constitute a huge frieze over seventy metres long and
just under four high, that is, he attempted to bring the commission
back to familiar ground. Although he wanted this work to be realist,
his absolute trust in appearances led him to the conviction that it was
possible to depict the characteristic aspects of each Spanish region in
the form of a group of figures arranged in the open air and transferring
them directly to the canvas, thereby offering a view of the country far
removed from the tormented gaze of Zuloaga and the '98 Generation.
What he produced was a gigantic picturesque vignette far removed
from the approach that materialised in his beach scenes, his
landscapes and even his portraits. The hall was inaugurated in 1926,
three years after the artist's death and when his reputation was on the
wane, as a result of which it did not cause the anticipated sensation.

THE BREAD FIESTA (CASTILE).
1913; THE JOTA (ARAGON). 1914.
The set of panels devoted to
Castile occupied most of the
frieze (fifteen metres and over
one hundred figures). It was also
the first the painter finished,
and for which he executed the
greatest number of preliminary
studies. Aragon, on the other
hand, was restricted to a panel
painted in the Valle de Ansó
(Huesca), depicting several
figures dancing the jota, the
Aragonese traditional dance par
excellence. Here we perceive
a far more academic sense of
composition and execution than
is usual in Sorolla, despite
the fact that the artist strove
to build his composition on
the basis of colour contrasts.
Sorolla's realism—"the verism
characteristic of my school", as
he called it-takes the form not
so much of exaltation of luminic
and atmospheric values as the
laborious task of documenting and
seeking traditional costumes and
characteristic types, an attitude
more in keeping with that of
19th-century historical painters
than with his own painterly
habits.

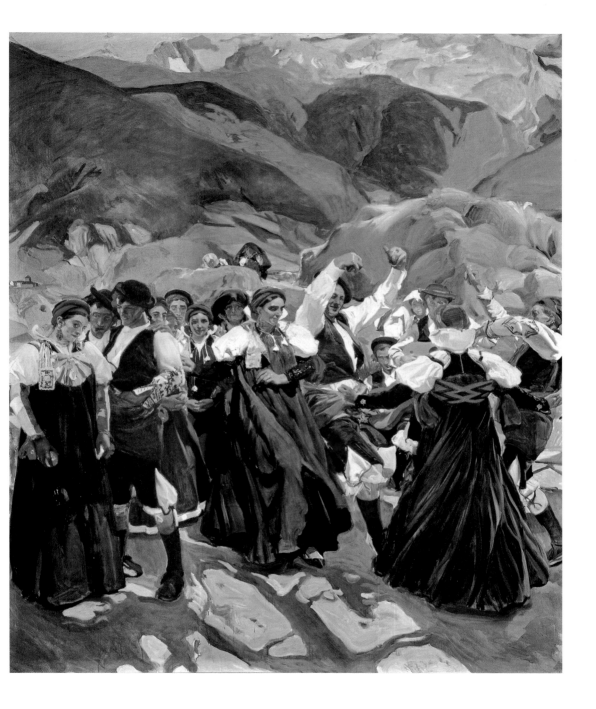

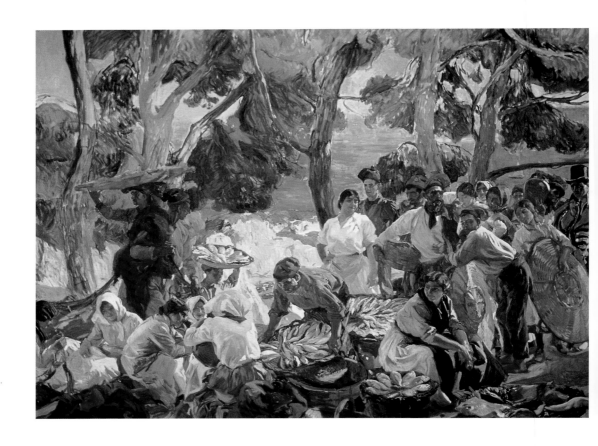

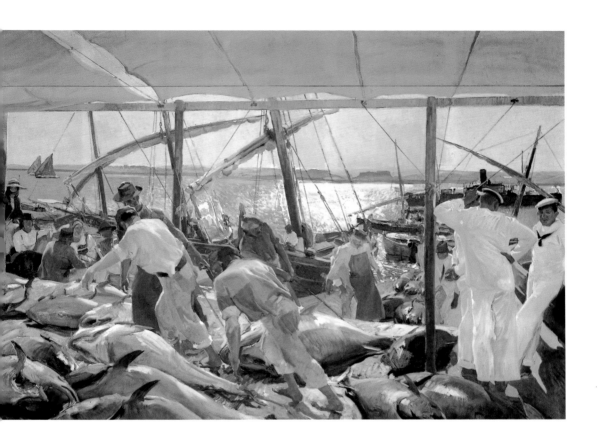

THE FISH (CATALONIA). 1915; THE
TUNNY CATCH. AYAMONTE. 1919.
When Sorolla addresses the light
of the Mediterranean, his New
York panels acquire greater
vitality, as in the one devoted
to Catalonia, in which we
appreciate connections with his
costumbrista seafaring scenes
from 1890. However, where his
characteristic style reappears
with greatest vigour is in the
last two panels of the series,

those corresponding to Elche
(*The Palm Grove*, 1918) and
Ayamonte. In this latter canvas
we once again encounter spatial
synthesis, clear tones, vibrant
light and some of the resources
characteristic of his most
personal painting, such as
the canvas that filters and
disseminates the light. Sorolla
himself, who painted this canvas
while struggling against his
deteriorating health, was aware,

as he explicitly stated, that
this was the best of the series
and the one closest to his way
of understanding painting. His
pupil Santiago Martínez, who
never left his side at this
time, relates how the master,
on the point of finishing the
picture, shouted out to him
and exclaimed: "Look, son! Look
at this example of Valencian
painting! It could be an
Emilio Sala!"

SOROLLA'S PORTRAITS

"I dislike painting portraits, unless it's in the open air" Sorolla once said to an American journalist in 1909. Nonetheless, he applied himself to a genre that, although he undoubtedly regarded it as highly conventional, provided him with a handsome income made gain him a solid reputation. Once again, the United States played a decisive role here: Huntington commissioned him to paint a series of portraits of prominent figures in Spanish culture that contributed to establish his reputation in this genre, to the point that he even came to be compared to Sargent, the portraitist most in demand at the time. Indeed, the stamp of the American painter is visible in Sorolla's portraits. Both Sargent and Sorolla belong to the tradition of mundane, elegant portraits whose remote origins lie in the work of Velázquez, and the more recent ones of Manet. Sorolla was invariably a painter of appearances—or of the emotions that these appearances aroused in him—for which reason he was often reproached for not penetrating the psychology of his sitters. Although today this aspect of his oeuvre is not regarded as the most important—except perhaps in the portraits of his family or close friends—the extraordinary quality of many of his portraits cannot be overlooked.

BENITO PÉREZ GALDÓS. 1894; AURELIANO DE BERUETE. 1902. Despite the rather rough execution—even taking the painting's early date into account—the portrait of novelist Pérez Galdós reveals Sorolla's talent when it came to elude the conventions of the genres in which he was engaged. The immediacy and realism of the subject is achieved by the background, composed of juxtaposed plans that allow the volume of the figure to generate the pictorial space. Beruete, the most important Spanish landscape painter of the time, was also an intimate friend of Sorolla's and one of the people who strongly encouraged him to cultivate portrait painting. The Velázquez-like quality of the work denotes a terrain common to both artists, for Beruete—who was also an outstanding critic and historian—wrote a major monograph on the Sevillian painter that was published in Paris in 1898.

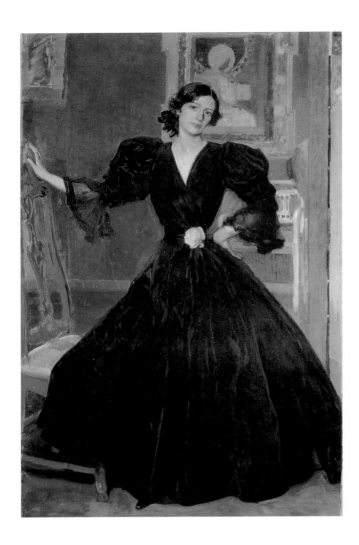

CLOTILDE IN A BLACK DRESS. 1906;
PRESIDENT TAFT. 1909. Clotilde
posing as a grand dame, wearing
an elegant black evening gown,
is a fine example of how
Sorolla, with his own weapons,
encroached on the terrain of
the mundane portrait of
Sargent. Executed with greater
naturalness than other similar
commissioned portraits, the work
shows how Sorolla addressed the
textures and nuances of black,
in contrast to his open-air
paintings. There is a photograph
of Sorolla painting this
portrait, showing how in these
cases his procedure was highly
conventional. First he would
carefully draw the features
of his model and the folds of
the dress in charcoal before
applying colour. The commission
to paint the portrait of
the President of the United
States came as a result of the
extraordinary success of his
New York exhibition of 1909.
Sorolla lived for six days at
the White House with the Taft
family—who spoke Spanish—,
where he established a good
relationship with the president,
whose genial nature is perfectly
captured in this canvas.

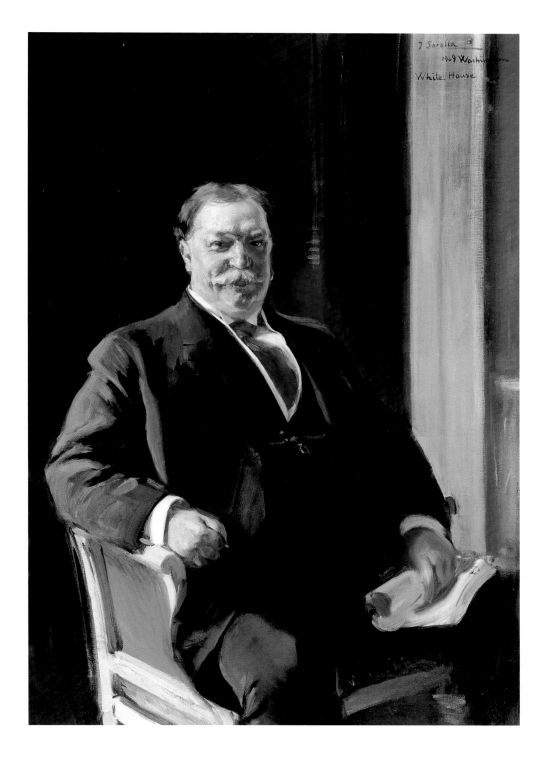

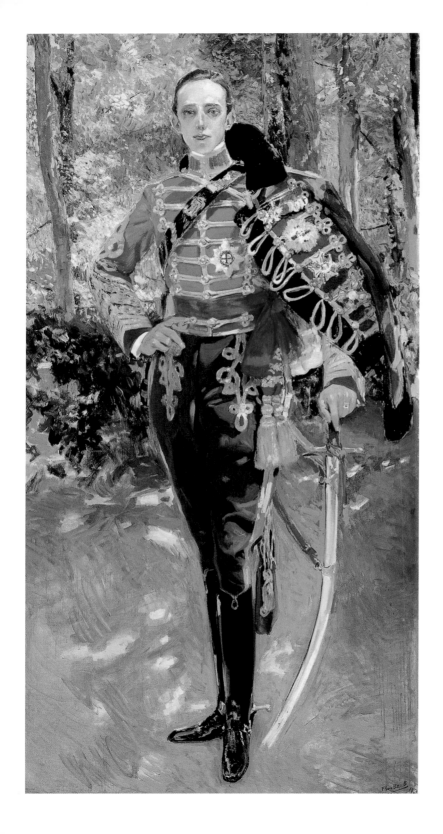

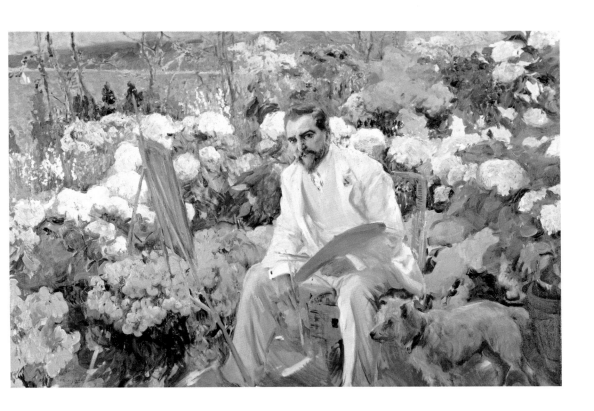

ALPHONSO XIII IN HUSSARS UNIFORM, 1907; LOUIS COMFORT TIFFANY, 1911
As Sorolla himself stated, the open air was the terrain in which
he felt most at home when cultivating the portrait genre. His 1907
painting of King Alphonso XIII in the gardens of La Granja is the
most famous, and first work of this kind, whose subject was someone
other than the members of his family. Less well known is his
portrait of the American artist and designer Louis Comfort Tiffany,
the commission for which was also the outcome of the 1909 New York
exhibition. Sorolla painted Tiffany in the gardens of Laureton Hall,
the sitter's Long Island home, and like that of Alphonso XIII, it
shows how in his open-air portraits the Valencian painter managed
to break new ground, far removed from more conventional forms of
portrait painting.

LIST OF WORKS

SELECTED BIBLIOGRAPHY

Catalogue for the exhibition «Fondos
del Museo Sorolla». Zaragoza, 1995.

Catalogue for the exhibition «Sorolla».
Fundación Mapfre, Madrid, 1995.

Catalogue for the exhibition «Sorolla-
Zorn». Museo Sorolla, Madrid, 1992.

Catalogue for the exhibition «Sorolla-
Zuloaga. Dos visiones para un cambio
de siglo». Fundación Mapfre, Madrid,
1998.

Pantorba, B. de, *La vida y la obra
de Joaquín Sorolla.* Madrid, Mayfe,
1970 (1953).

Peel, E. (coord.), *Joaquín Sorolla y
Bastida.* Barcelona, Ediciones
Polígrafa, 1990.

Pons-Sorolla, Blanca, *Joaquín Sorolla.*
Ediciones Polígrafa, Barcelona, 2005.